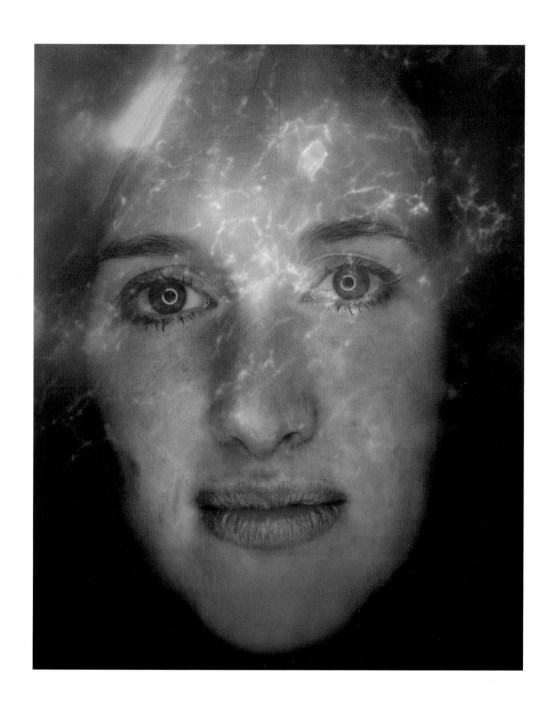

Wonder Chamber

Karen Ingham

Published by Ffotogallery Wales Limited
Ffotogallery, c/o Chapter, Market Road, Cardiff CF5 1QE

ISBN-13 978 1 872771 89 2

Published March 2012 to coincide with the exhibition:

Karen Ingham *Wonder Chamber*

10 March – 14 April 2012

Ffotogallery, Cardiff

All Images © Karen Ingham

All text © the authors 2012

Publication design: Phil Thomas

This publication has been made possible thorough the kind
support of Swansea Metropolitan University and the
Arts Council of Wales.

Wonder Chamber

KAREN INGHAM

Foreword

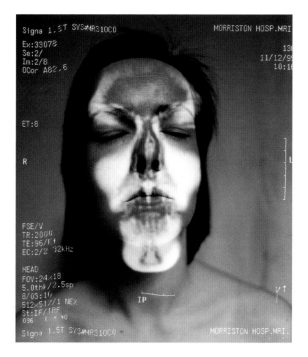

'Morphology III', from *Death's Witness* (2000)

Over many centuries artists and scientists alike have wrestled with the challenge of representing the natural world in visual form. In this endeavour, art has been greatly influenced by prevailing ideas and practices in science, and vice versa, from the Renaissance to the beginnings of modern photography, from the botanical drawings of the early Victorians to the latest developments in quantum physics.

As Siân Ede has commented in her eloquent writings on the subject, it is more common for today's scientists to talk about the 'beauty' and 'wonder' in their work than it is for contemporary artists. In addressing difficult questions about human nature, scientists have not only gained new insights into the inner workings of our minds and bodies, but also into how we construct our identities and selves. Contemporary science continues to provide us with beguiling metaphors and new paradigms for viewing the world.

Karen Ingham is an artist with an enduring interest in the natural sciences and how scientific ideas and processes inform contemporary image making. Her interest in what she calls "obscure science" was awakened at an early age by her family's involvement in the Spiritualist church, a milieu in which 'scientific' method and ritual combined to magically transform physical objects into vehicles for communication with the departed. She remains captivated by the roles that phenomenology and illusion play in science, as opposed to more rationalist and empirical approaches to scientific

enquiry. Beyond the relevance of such ideas and narratives to her practice as an artist, Ingham's work draws directly on the patterns, forms and structures of scientific image making.

Presented for the first time at Ffotogallery in Spring 2012, *Wonder Chamber* brings together various bodies of work produced by Ingham over the last decade in the form of "an imaginary museum with its interconnected spaces for the display of seemingly disparate and eclectic objects and artifacts". This premise for an exhibition is particularly apt for an artist whose practice is divergent and interdisciplinary in nature, but always grounded in photography and lens-based media, in its various forms.

The *Wunderkammer*, the original Wonder Chamber, sought to create order out of the chaos of nature and introduced a standard classification system for the diverse and often bizarre collections on display in 19th Century museums. A key element of Ingham's practice is to play on and subvert the standard taxonomic categories of science museums and scientific exhibits, putting them in the service of contemporary art. In this regard her practice can be located within a long lineage of 20th century artists – from Duchamp and Broodthaers to more recently Susan Hiller and Martha Fleming – whose work has challenged both the 'scientific' taxonomies of the museum and received definitions of the 'art object'.

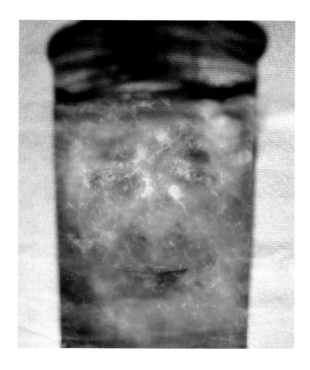

'Captured Thoughts' (2011)

In Ingham's case, this questioning of the linear way we collect, archive and display objects, and how our experience of the natural or artificial world is mediated by particular narratives, reflects both her interest in the paradoxical relationship between photography and scientific positivism, and her belief that the traditional boundaries between art and science are becoming increasingly blurred and arbitrary in a digital age.

For Ingham, the hybrid nature of digital media offers both a new form of pictorial illusion and an exciting performative space in which to work. She recognises the immense power of technological tools which can translate into a single digital code our economic systems, social interactions and how the world looks to the eye, allowing us to experience, travel between and transmute things that were previously disparate. Through modern science, computers and Web environments, everything including our bodies can ultimately be understood in terms of a universal code – the human genome. Alongside her exploration of earlier scientific ideas and phenomena, Ingham embraces the creative potential of these new image making technologies and their mimetic properties, whilst remaining mindful of the ethical, moral and spiritual implications of these seismic developments.

By looking forward and looking back at the history of science, Ingham's work reminds us that scientific progress relies as much on imagination and creativity as physics and mathematics. Engaging with science, playfully mimicking and reconstructing its ideas and methods, the artist sheds light on the complex process of technical, biological and cultural formation that shapes our futures, and defines human experience.

David Drake
Director, Ffotogallery

A Strange Crossover
Ken Arnold

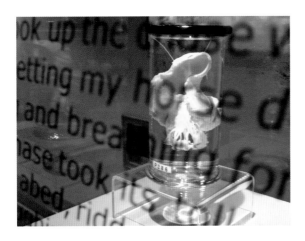

"[It is not] by painting that Photography touches art, but by Theatre… [It is] a kind of primitive theatre, a kind of *Tableau Vivant*." Roland Barthes, *Camera Lucida* [Fontana Paperbacks] pp. 31-2

Karen Ingham makes *Tableau Vivant*. If we are happy to accept Barthe's suggested likeness between photography and theatre, then this observation amounts to little more than a straightforward statement of fact about an artist whose work is extensively 'lens-based'. But it is worth mulling over, because it can help us unpack what her image-making entails. Much else happens before and after, but like anyone who uses a camera, she often starts by simply 'taking' pictures. What lingers in many of her works is a strong sense of what originally spurred her into those acts of visual appropriation: something of what was at the scene *before* she got there. The lenses at the heart of so much of what she does serve to arrest real moments in time and space: aspects of rich and intriguing places that animate forensically specific ideas. Those ideas are both derived from and then reinserted into an interdisciplinary context – caught somewhere between artistic invention, scientific discovery and technological construction. The final ingredient stirred into some of her artworks, which simultaneously captures these haunting moments and that toys with complex notions, are vibrant voices.

Lenses

Ingham's artworks frequently draw on an acute awareness of the history of science, particularly the biological sciences. In a time that saw the parallel emergence of photography, physiology, technical museums and a positivistic philosophy, lenses and other image-making technologies began gradually to furnish researchers with a means, confidently, to see and understand things that are invisible to the naked eye. Particularly fascinated by the realm of knowledge that this modern science hatched, she is drawn time and again by its trained habits of looking (either with unaided eyes, or assisted by technical tools), and by the underpinning vocabulary and key assumptions that have gradually been taken for granted, on trust. For example in recent neuroscience, particular thoughts and behaviours are more readily and almost routinely described as being located in specific parts of the brain that can be seen 'lighting up' under stimulus. Working with this sort of material, but often across if not against its natural grain, her own lens-based practice seeks to explore the frequently hidden nuances of interpretation and meaning that lurk just below the surface of its posited reality.

It was the French physiologist Claude Bernard who succinctly observed that while 'Art is I. Science is we'. The scientific urge to ignore irregular instances in favour of the predictive and explanatory power of objective generalisations is seemingly inverted, maybe necessarily, in the artistic inclination to champion individual subjective perspectives.

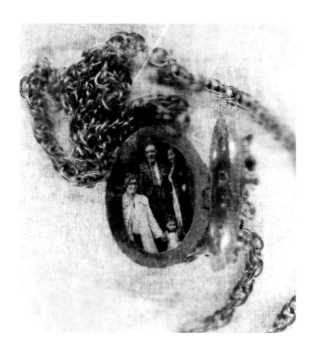

'The Locket', from *Death's Witness* (2000)

But even in science, beholders can be prone to observe what they are looking for; and in art, autonomous creativity invariably seems to fit into broader styles and movements. Like others who simultaneously turn for inspiration to both science and the arts, Ingham's work is caught in a tussle between subject and object, between arms-length observation of samples and the deeply personal process of reacting to things that shape who we think we are.

In her work 'Variance' for example, she has created large-scale photographic 'thought portraits' that incorporate scanning and confocal electron microscopy images of brain activity. This series was inspired by her studies of Francis Galton's obsessive statistical measurement – he famously judged the quality of a lecture by the amount of fidgeting he recorded in its audience – and especially by the collections of glass eyes and composite typologies preserved in University College London's Galton archive. Ingham's set of images tackle its eponymous idea through seemingly opposite visual suggestions. On the one hand, identifying something unique in generalised biostatistics and, on the other, inserting something scientifically objective within a 'portrait'. As she herself says of the piece: it reflects how "contemporary neuroscientists are becoming more metaphorical ('artistic' one could say) in the way that they talk about the mind and the brain, while artists seemingly become more objective… a strange crossover".

Another of Barthes' key observations about photography was to assert that "the photograph is never anything but an antiphon of 'look', 'see', 'here it is'; it points a finger at certain *vis a vis*." But what it asks viewers to look at is, of course, eternally uncertain, always prone to their own subjective inclinations, and further heightened by the photographer's sleight of hand. The fact that the invitation is to look *through* a photograph at what it actually is, rather than be satisfied with its surface detail, makes photography something fundamentally tricky. Barthes again, in his provocative way, insists that "whatever it grants to vision and whatever its manner, a photograph is always invisible: it is not it we see." This idea of an essential, pictorial illusion pervades and indeed is celebrated in much of Ingham's art, where lens-based practices are used as tools to manufacture what might not quite be as it appears. For her, the real and the imaginary – the play between surface semblance and underlying meaning – are often blurred, creating hybrid meanings in hybrid media. In her recent work 'Piece of Mind Mask' for example, she creates a series of illusionistic masks, redolent of something that we might associate with a Venice carnival, but which are in fact derived from images of primate brain slices. The visual similarity between sections of 'grey matter' and props for an entertaining ritual suggested the final form of the work: a set of masks playfully expressing displaced medical curiosities. Ingham adds a concluding twist to this piece by encouraging her audience to become co-producers of the masque-ball, providing them with an on-line

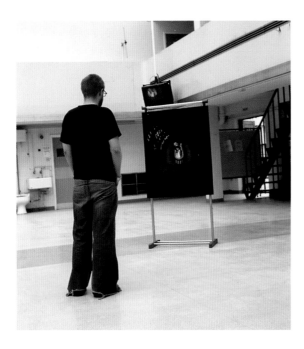

Installation shot from Cardiff Dissecting Rooms, *Anatomy Lessons* (2004)

facility to download the masks, and finally inviting them to contribute photographs of themselves wearing the brain-slice masks.

Places

There is also something quintessentially public about Ingham's art. Not only is it very much made with a public in mind, but it also often incorporates elements of the public realm within the work itself – masquerades, museums, cinemas. Her art then is at once an exploration of her chosen subject matter and of the very tradition of publicly sharing those topics. As such, it refreshingly flies in the face of a pervasive fallacy - the 'fallacy of dissemination' maybe – found in both science and art circles: namely that making something public need only involve opening up a private creation or insight for general inspection. For some, the suspicion aroused by the effort and artifice involved in genuinely making work in public – preparing a lecture, hanging and lighting a show, editing an article, framing a work, and so forth – has led to a disregard for this part of the creative process at all: seeing it as, at best, a trivial form of 'show business', and at worst, a deceptive trap leading inevitably to misrepresentation. Not so for Ingham, however, whose practice echoes the findings of a number of recent histories of art and of science, which show how since the Renaissance, both realms have been inextricably associated with their public faces; suggesting indeed that modern forms of science and art were effectively defined in public terms – science that could be refuted, or not, and art that could be

admired, or not, by *any* citizen.

An important early modern focus for this effort to make ordered public knowledge from fragments of individual understanding came in the form of 'cabinets of curiosities'. These fledgling museums exemplified an essential idea of using them to reach out and forage in the worlds of natural and artificial things – selecting and bringing back the most curious and wonderful – and then play with ways of cogently arranging them for public consumption. A reworking of this long-standing set of acquisitive and demonstrative pursuits is especially evident in some of Ingham's work. Her keen sense of the potent magic waiting to be found in seemingly ordinary objects that turn out to be truly wonderful may, as she herself suggests, have been inherited from a family background soaked in spiritualism. Predisposed to marvel at the puzzling curiosity and intrigue inherent in their contents, she is also concerned with the role of Wonder Chambers in ordering the world's seeming chaos, what Ted Hughes marvellously termed "A huge agglomeration of upset."

Developing these interests, Ingham was again able to draw on first hand research, conducted this time during her Wellcome-funded 'Anatomy Lessons' project. In 2004/5 she travelled to a wide variety of anatomy museums across Europe and beyond. "Usually," she says, "when people go to anatomy museums they are drawn to the exhibits." But for 'Anatomy Lessons', she was far less compelled by the curiosities themselves. Instead, what she really

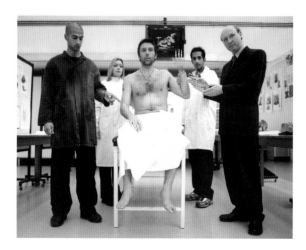

'The Anatomy Lesson of Professor Moxham' from *Anatomy Lessons* (2004)

wanted to look at were the spaces that housed them, the empty dissecting rooms. What emerged was a project that explored how those spaces could be allowed to speak. Less concerned, she says, "about specific dissections of bodies and the particular histories that hang off them, [her focus here] was much more on the actual spaces, deeply, deeply drenched in that collective history".

So the places in which Ingham's work is seen are significant and indeed end up providing a crucial aspect of the experience of the pieces themselves. And in this exhibition she has carefully created different spaces in which they are contextualised: a 'now you see it, now you don't' chamber in which natural history is the core subject; and another themed around 'variance' and 'the anatomy collection', where the work and the context in which it is viewed allude to expectations associated with the public face of how natural and medical sciences are practiced. This more performative space conjures up a 'theatre of the mind' and even more specifically an internal 'Cartesian theatre', as defined by Daniel Dennett: that is, an imaginary room inside our heads where our conscious selves (a homunculus or miniature us inside our own brains) can observe the processed sensory inputs we receive and fashion them into a coherent account of the world, all presented as a kind of never ending movie.

Drawing on this range of showy pursuits, Ingham encourages us to adopt a particularity and granularity in the way we look at these formalised spaces – museums, galleries and anatomical theatres, as well as laboratories and artist studios – which have been demanding the attention of their visitors and users for hundreds of years now. But there is another resonance for her in the particular form of the wonder chamber (her image-filled imaginary museum), which lies in the specificity of the word chamber itself, a rather direct reminder of her central concern with lenses. For cameras originally emerged from the preparation of dark rooms in which the image-forming potential of focused light was admitted and then trapped: the *camera obscura*. Ingham's art basically works in the way that all photographs do, making 'chambers' for her subjects – spaces walled off from diverting distractions by the limits of the field of view inscribed in her reproduced images. Ultimately her *tableau* provide discrete places in which to indulge the mind's eye.

Stories

Ingham is concerned with how pictures and spaces feed cyclically off each other, with the flat surfaces of her images quickly giving way to suggestive places within. And this in turn gives a richness to these places – lending them a palpable presence that is mostly hidden away in the austere structural containers that host the medical and scientific procedures that she wants us to observe and contemplate. This is another key ingredient of her art: storytelling.

A project that brings this animating strand of practice to the fore is 'Narrative Remains' – an

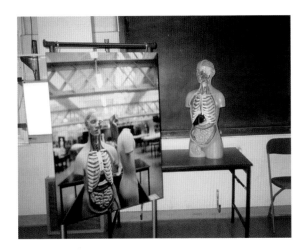

Installation shot from Guy's – Kings College London Dissecting Rooms, *Anatomy Lessons* (2004)

exhibition, film and publication presented in London's Hunterian Museum in 2009. Using texts and images, it effectively reunited some of the organs displayed there with their 'patient narratives' – stories, as so commonly is the case in such institutions, that had become misplaced if not altogether discarded. Her accompanying scripts, often drawing on the barest morsels of evidence, provided a sense of humanity rediscovered within a single organ, a heart for example. In another, the story grew out of a distinctly mute oesophagus, larynx and trachea, which gave voice to the tale of Marianne Harland – a young singer, who lost hers, and her life, to tuberculosis. Here too lurks a *modus operandi* that someone familiar with spiritualism might be able to draw upon rather directly: the ability, that is, to detect a remnant agency in some physical remain and then artfully channel it to disclose the story of a person seemingly dead and far gone. These acts of re-attaching stories clearly suggest an unmistakable gesture towards wholeness. But the fact that they have initially been analytically separated, that a gap inevitably lingers between the disembodied story and semi-anonymous organ, remains striking. There is a potent sadness about it that we want, maybe need to hang on to. The complete effect then is not just to reunite story and subject, but rather to enable both to gain from the longing that each has for the other. Drawing directly on the solace of catharsis then, the energetic and emotional moments of reunion are all the more poignant because we know that the specimens will slowly slip towards anonymity again.

In other works, stories spring from apparently mundane objects, sometimes ones that have been discarded in the corners of medical/scientific spaces rather than deliberately preserved for posterity. A tray of dissecting pins in the Royal College of Surgeons in Edinburgh, for example – "objects [she suggests,] that you would just pass by … [without giving] a glance to otherwise: no names, no histories, no agendas" – "absolutely have, [she insists,] their stories and speak, in a sense, for themselves..." Here too her work touches on a tension between the dominant medical inclination to separate object and subject and the opposite more recent preference to remember and hold onto patient narratives. In truth, her stories are polyvalent with overlapping layers of fictive narrative, history, scientific insight and philosophical contemplation. As a result, Ingham's engagement with storytelling manages quickly to get away from the unthinking assumptions we have that fact and fiction, observation and narration, science and art, learning and emoting somehow stand in opposition. Even in the complex and very technologically advanced world of contemporary science, Ingham uses her *tableau vivant* to remind us that "there can be a joy and a wonder about what you are looking at, even if there is not complete understanding in advance: an invitation to imagine and speculate."

Dr. Ken Arnold is Head of Public Programmes for the Wellcome Trust Wellcome Collection and is author of Cabinets for the Curious (Ashgate Publishing 2006)

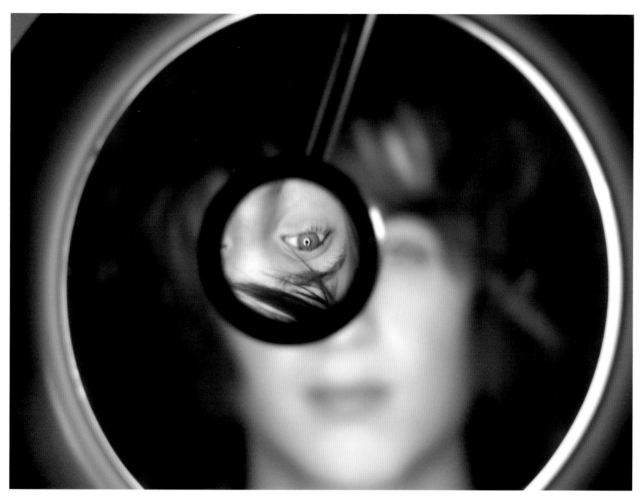

'Mind's Eye I', (2010)

Polly Gould (2003)
Nature and Nation: Vaster Than Empires

❝It is through the way that histories are imagined, classifications and namings articulated, metaphors applied, that certain instrumental approaches to the world, nature and peoples are crystallized❞

The Unnatural History Gallery

'Bunny Vanitas' (2008)

Unnatural Histories

The images in the Unnatural History Gallery play on the complexity, perhaps even the absurdity, of trying to collect, preserve, and archive nature within the institutional museum space. This is suggested by the images 'Specimen' (2008) from the Natural History Gallery at the National Museum and Gallery of Wales Cardiff and 'Girl Drawing Bat' (2010) at the Grant Museum of Zoology in London. The images from outside the museum space are 'Dead Bird-Still Flying' (2008), 'Bird Mask' (2008), and 'The Scream' (2009), which allude to an altogether more random and chaotic natural world captured and collected as a photographic taxonomy.

Cabinet: Now you see it ...now you don't

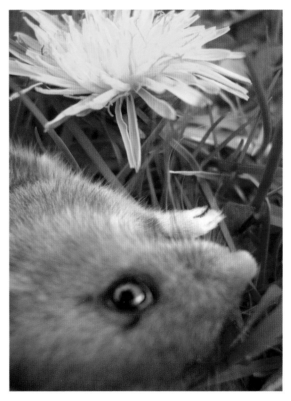

'Mouse Vanitas' (2008)

'Cabinet' plays on the illusionist's sleight of hand, the classic hide, switch and reveal, only it is not dice or balls that are the objects of trickery but birds and butterflies. As increasing numbers of winged pollinating species become endangered the objects act as an allegory of environmental fragility; just like the legendary dodo - 'now you see it, now you don't'.

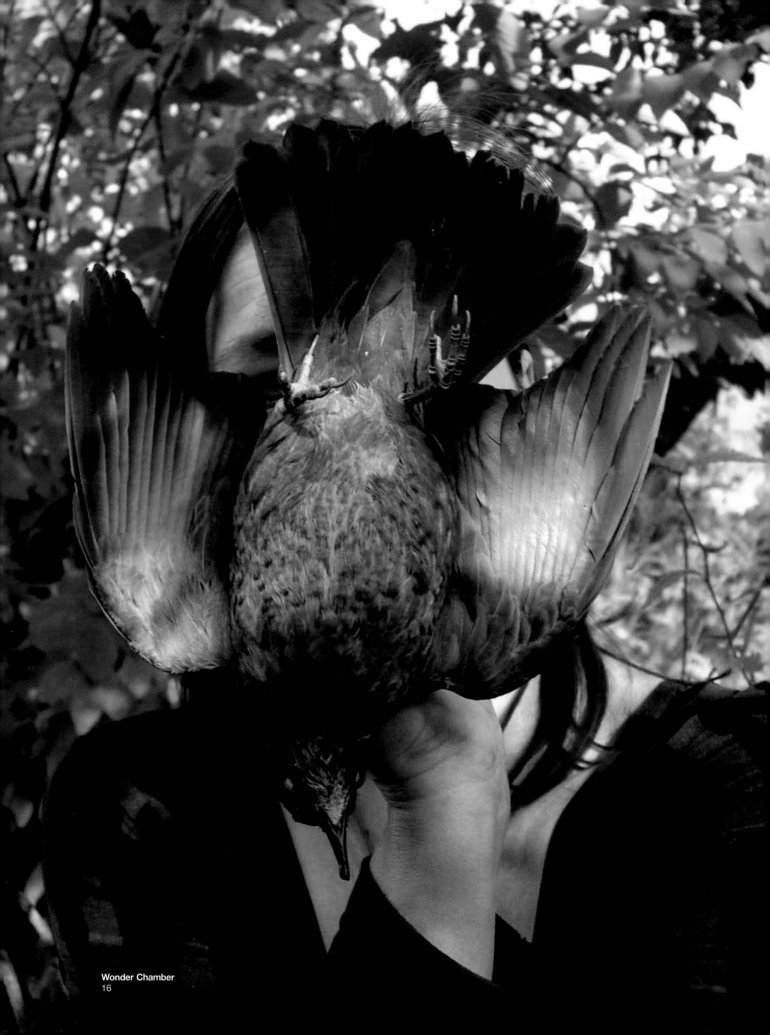

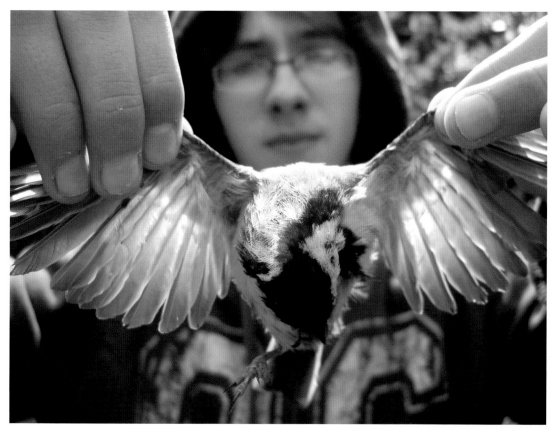

'Dead Bird (Still Flying)', (2009)

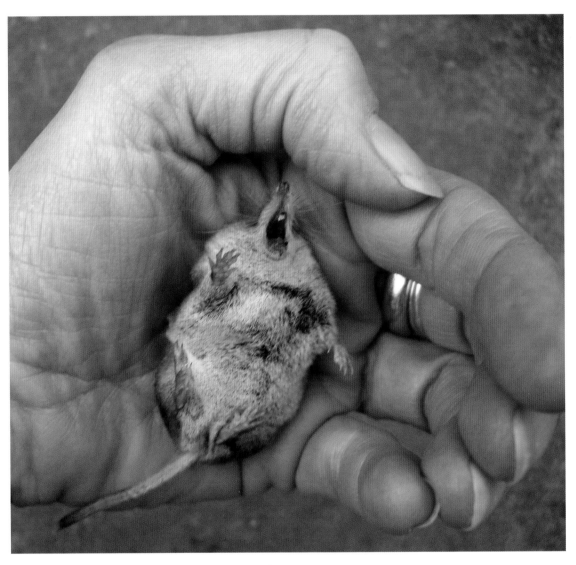

'The Scream', (2010)

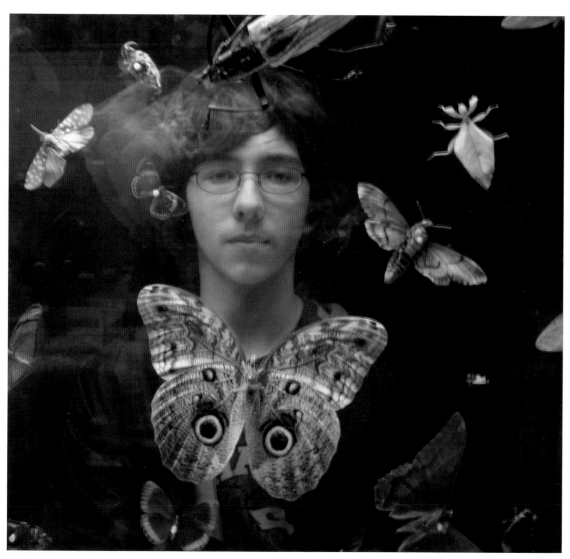

'Specimen', Natural History Gallery, Cardiff Museum, (2008)

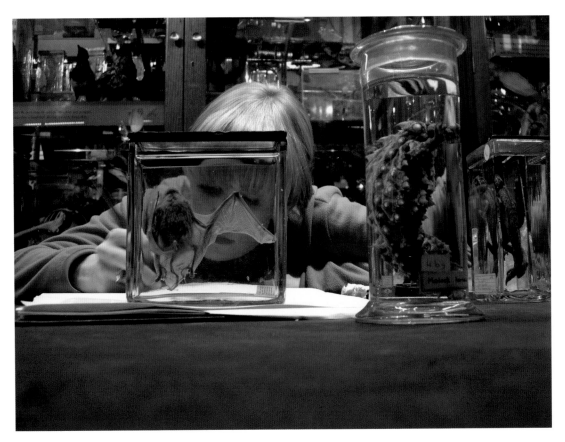

'Girl Drawing Bat', Grant Museum of Zoology, (2010)

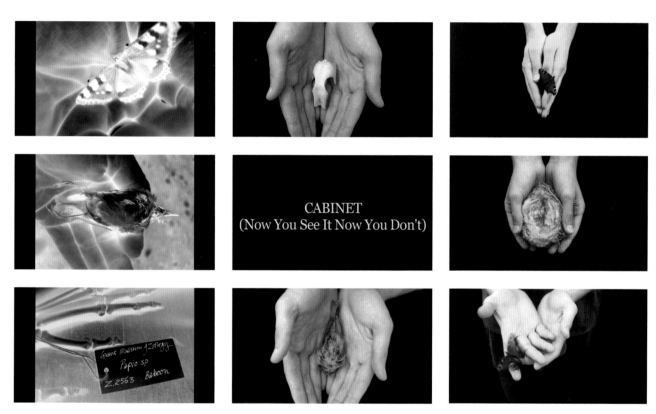

Film stills from 'Cabinet', (2012)

Rina Knoeff (2011)
The Visitors View: Early Anatomical Exhibits and the
Polyvalence of Anatomical Exhibits

❝Most importantly, anatomical exhibits were accompanied by narrative: that is, visitors interacted with anatomical preparations through exciting and puzzling stories...Like the many facets of a diamond, they meant different things at the same time, sometimes even to the same person❞

The Anatomy Collection

Narrative Remains

A Wellcome Trust funded collaboration with the Royal College of Surgeons' Hunterian Museum London, 'Narrative Remains' (2009) was a site-specific response to six key human specimens within the Hunterian collection. By writing a semi-fictional first person post-mortem account of their death and disembodiment, the 12 minute film relocates, re-embodies and reunites the lost narratives with their dislocated organs by layering the body parts and their stories onto the absent, but visualised as present, body. The organs are thus empowered to perform their own story of corporeal demise and post-mortem preservation. The film follows the long tradition of spoken narration by the dead, narrations that are often absent from the museum space itself. The project included specially made museum vitrines, layered with image and text, in which the actual specimens were displayed.

'Narrative Remains' was a continuation of research over the past decade focusing on theatres of anatomy and dissection and followed on from the touring exhibition and publication 'Anatomy Lessons' (2004-5), which exhibited contemporary anatomical artworks back in the dissecting spaces in which they were produced. Included in 'Anatomy Lessons' were two key images that are presented in Wonder Chamber.

Dissecting Pins

'Dissecting Pins' (2004) represents the body as text, open to deconstruction, decoding, and reconfiguration, be that the body as flesh or the virtual body, reduced to bytes of digital data.

Teatro Anatomico, Padua

'Teatro Anatomico, Padua' (2004) is in itself a kind of Wonder Chamber: a Renaissance space where scientific enquiry was premised on dissecting, classifying, collecting and displaying the 'divine architecture' of the human body – a space resonant with wonder even in the absence of the body itself.

...whisper. ...g escapes the tortured ...s of my diseased... Where once ...was song there... ...rasping. W... ...re was speech... silence. Wh... ...nce there wa... beauty, pain. ...young son will never experience the fa...delights of his mother's pure, clear c... range, nor will he hear me speak his name. I cannot even utter the name of my killer, no more than the doctors could halt the all too rapid progress of this dreadful disease. And now I am enclosed in a world of perpetual silence, my throat opened and displayed for all the world to see.

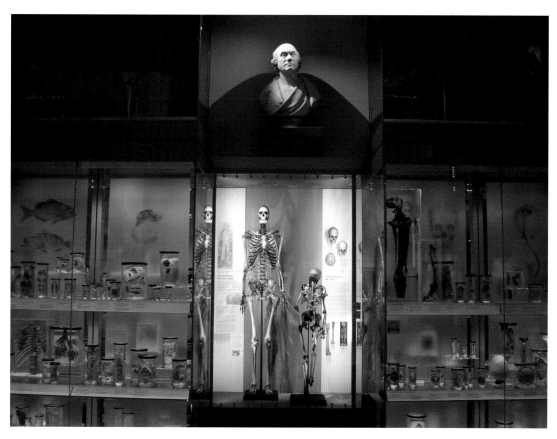

'The Crystal Gallery', Hunterian Museum London, (2009)

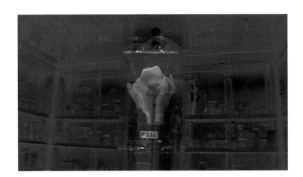

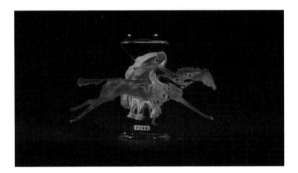

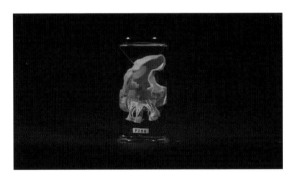

Film stills from the film 'Narrative Remains' (2009)

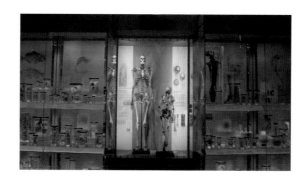

NARRATIVE
REMAINS

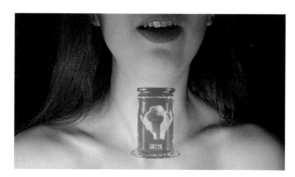

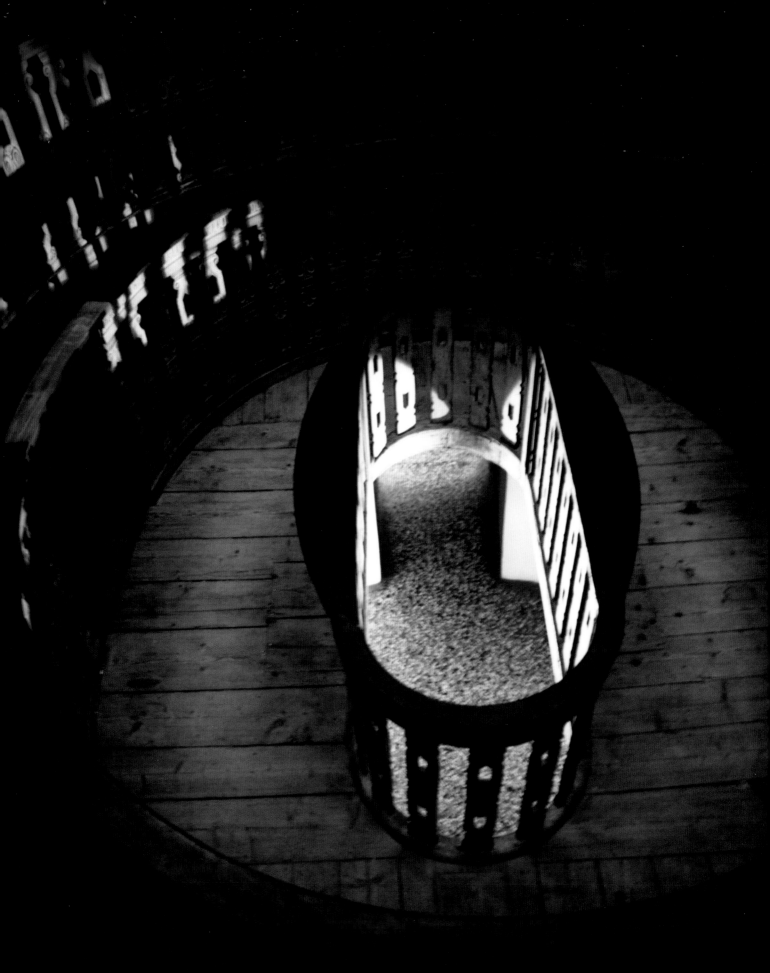

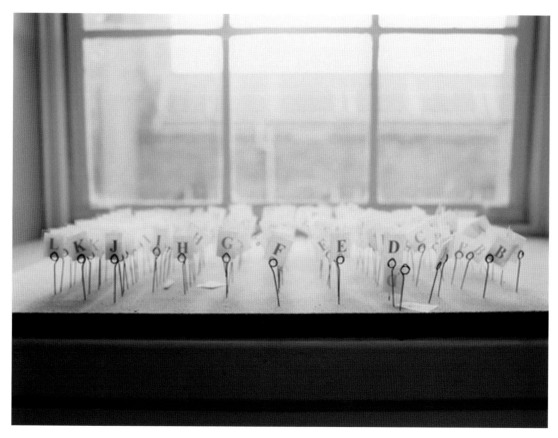

'Dissecting Pins', 2004

Left: 'Teatro Anatomico Padua', 2004

The function of these 'cabinets of the world' was twofold; firstly, to bring objects together within a setting and a discourse where the material things (made meaningful) could act to represent all the different parts of the existent; and secondly, having assembled a representative collection of meaningful objects, to display, or present, this assemblage in such a way that the ordering of the material both represented and demonstrated the knowing of the world

The Science Museum

The *Wunderkammer* and Cabinets of Curiosity
were closely entwined with the emergence of the
Enlightenment and the subsequent development of
European scientific inquiry and culture. The period of
the Enlightenment, characterised by intellectual
curiosity and empiricism, revolutionised our
understanding of science, but at a cost. During the
latter stages of the Enlightenment the belief in the
absolute authority of science led to a culture of
intolerance against those considered as 'outside' the
accepted conventions of the ruling elite. The
emergence of photography in the 1830s was
instrumental in perpetuating this culture through the
belief in the objectivity of the photographic medium.
This is reflected in the artworks included in 'The
Science Museum', several of which relate directly to
the research of Victorian polymath Francis Galton,
a focus of interest within my practice for over
a decade.

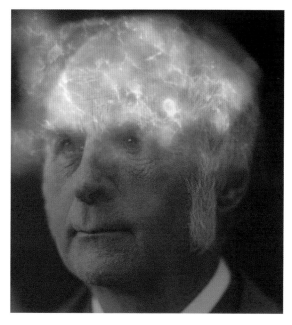

'Thinking Galton' (composite photograph of Francis Galton from UCL Galton
archive with contemporary medical imaging of neuronal brain activity), (2012)

❝A composite portrait represents the picture that would rise before the mind's eye of a man who had the gift of pictorial imagination to an exhalted degree. But the imaginative power even of the highest artist is far from precise, and is so apt to be biased...The merit of the photographic composite is its mechanical precision, being subject to no errors...❞

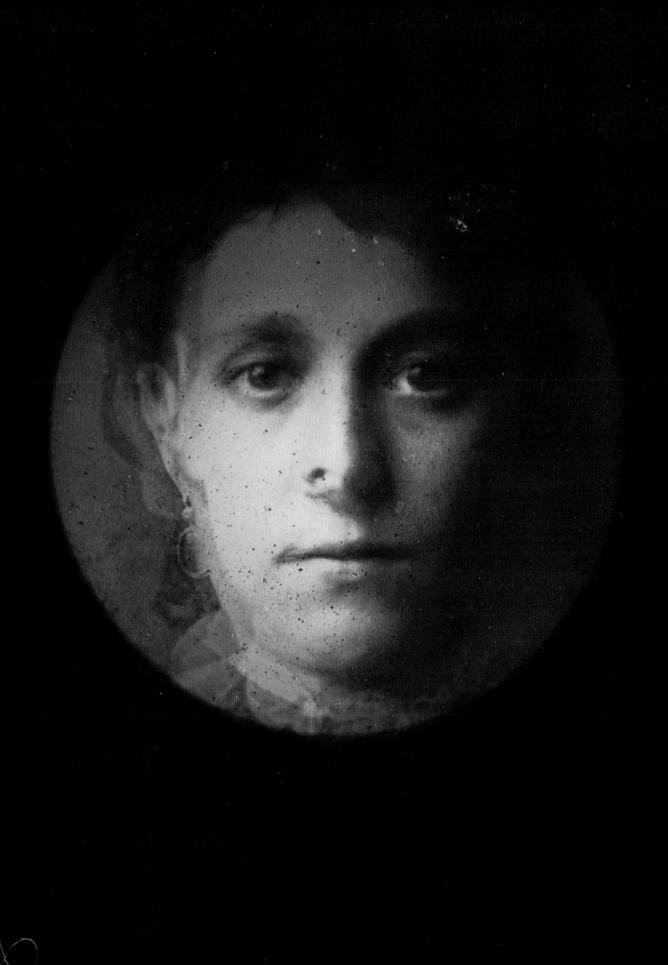

Composite Woman from the UCL Galton Collection, (2012)

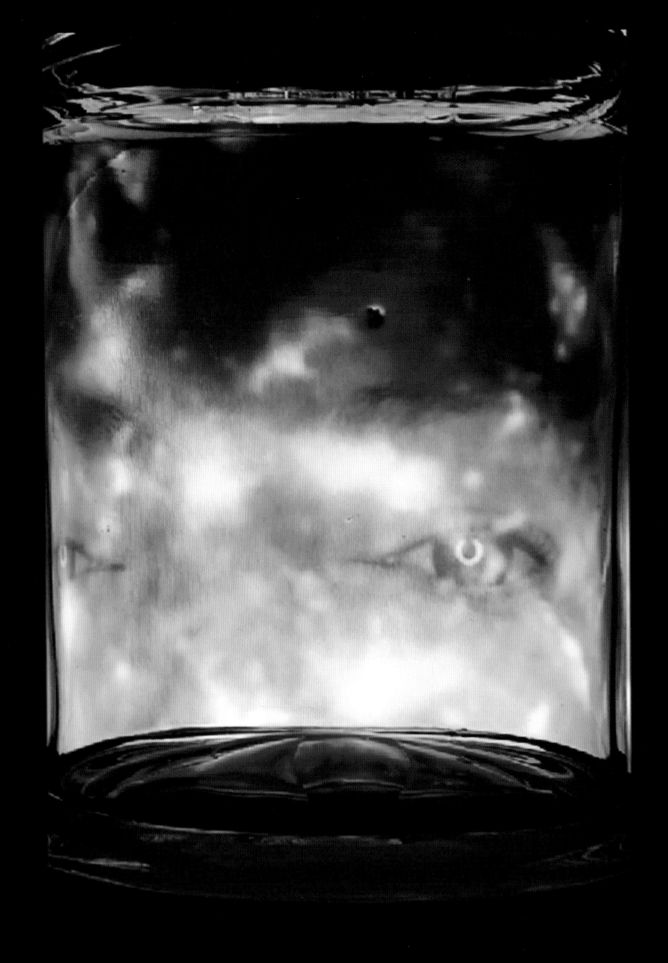

Variance

According to Elizabeth Edwards (1997) Francis Galton's composite photographs constituted "…lived concepts" – embodied or concrete ideas to render the unseen or non-existent empirically: in other words, a taxonomic essence within a dialectic of the visible and invisible." 'Variance' plays on this tension between the seen and unseen, the known and unknown, to comment on the impossibility of ever being able to construct human typologies in the way that Galton attempted. But 'Variance' is also influenced by Galton's anthropometric studies of inheritance (all six photographs are of my extended family) and his groundbreaking work on statistics and biometrics. 'Variance' incorporates scanning electron microscopy images of brain activity to create a series of 'thought portraits', which bring into question contemporary neuro-biological imaging technologies and interpretations, which allegedly allow neuroscientists to 'see' and 'measure' our thoughts and emotions. If a pain or sensation is not visible as a measurable correlate through an imaging process such as a magnetic resonance imaging scan, they suggest it isn't real: if not in the brain then it must be 'all in the mind'. Although most scientists do not subscribe to this extreme biometric neuro-realism, there is a danger that an unquestioning belief in the veracity of neuro-biological imaging threatens to return us to the days of positivist science and the disembodied philosophy of Cartesian dualism. This is a subject that references the history of photography and the relationship between optical and scientific imaging, in which theories of embodiment have become increasingly devalued.

Made with assistance from the Cardiff Neuroscience Research Group and University College London Galton Collection.

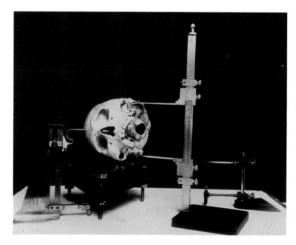

Film stills from 'Variance', (2012)

Left: Film still from 'Variance', (2012)

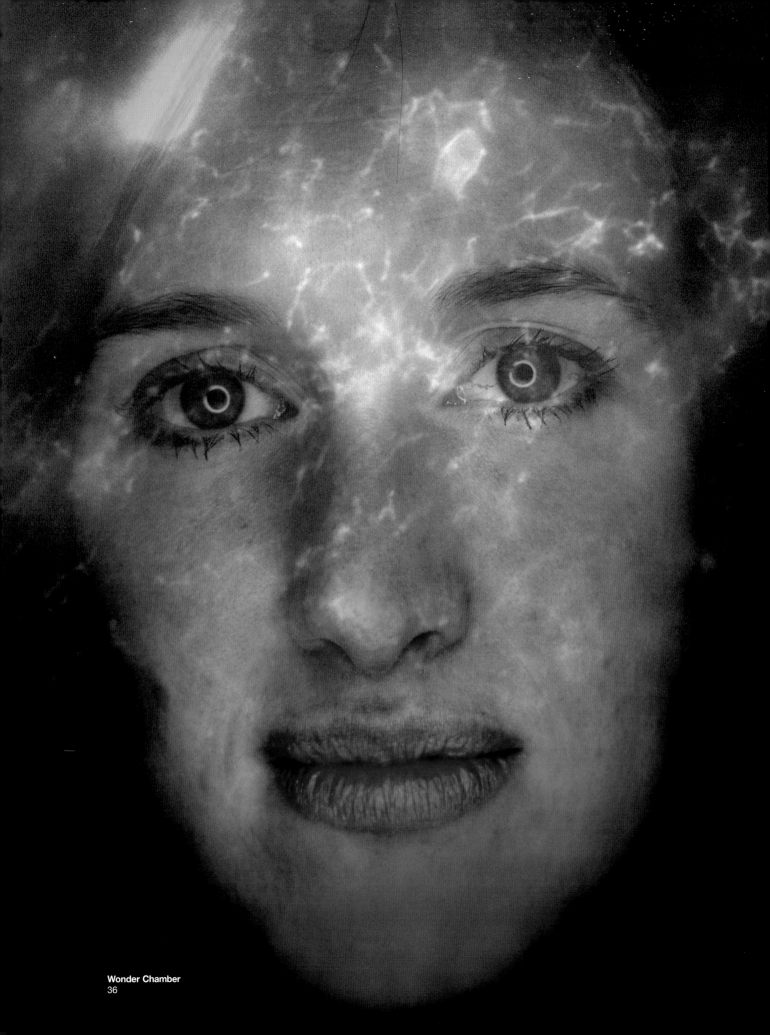

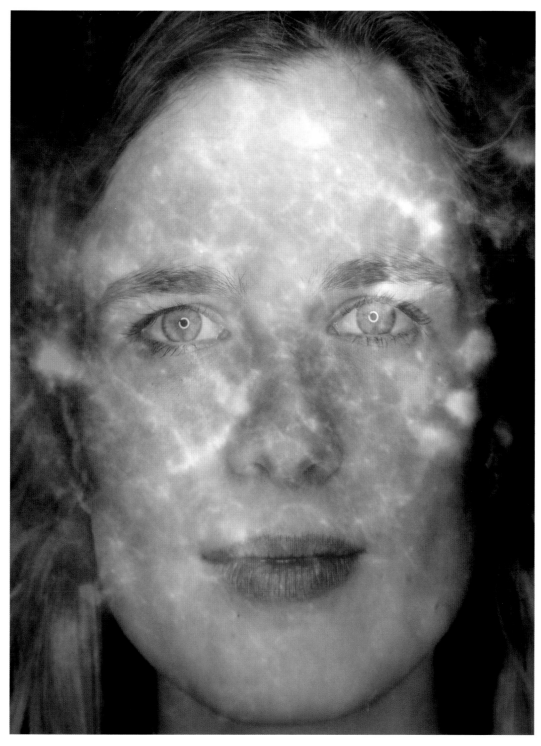

'Thought Portrait: Emily', (2011)

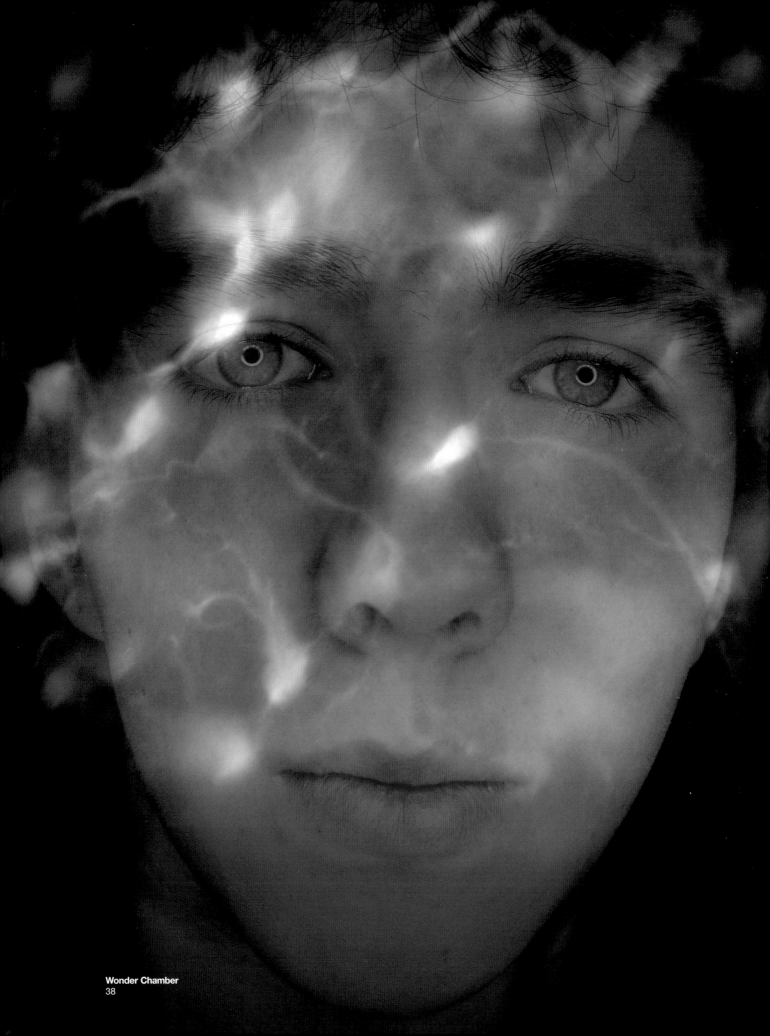

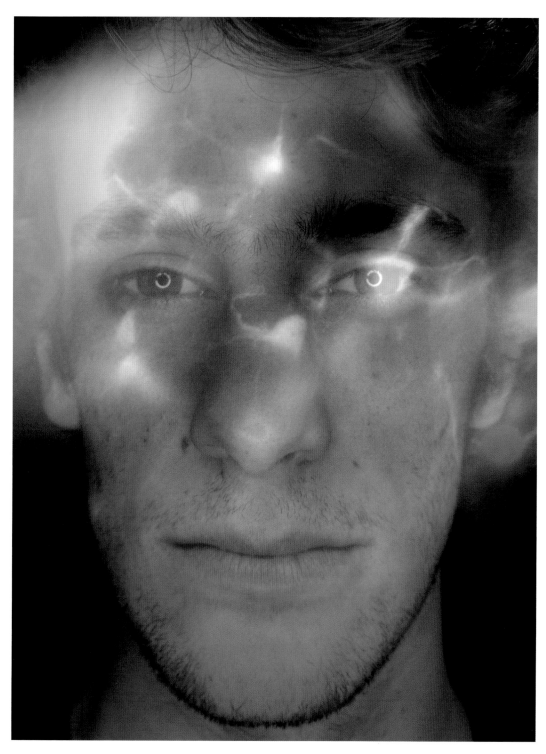

'Thought Portrait: Hunter', (2011)

Left: 'Thought Portrait: Harley', (2011)

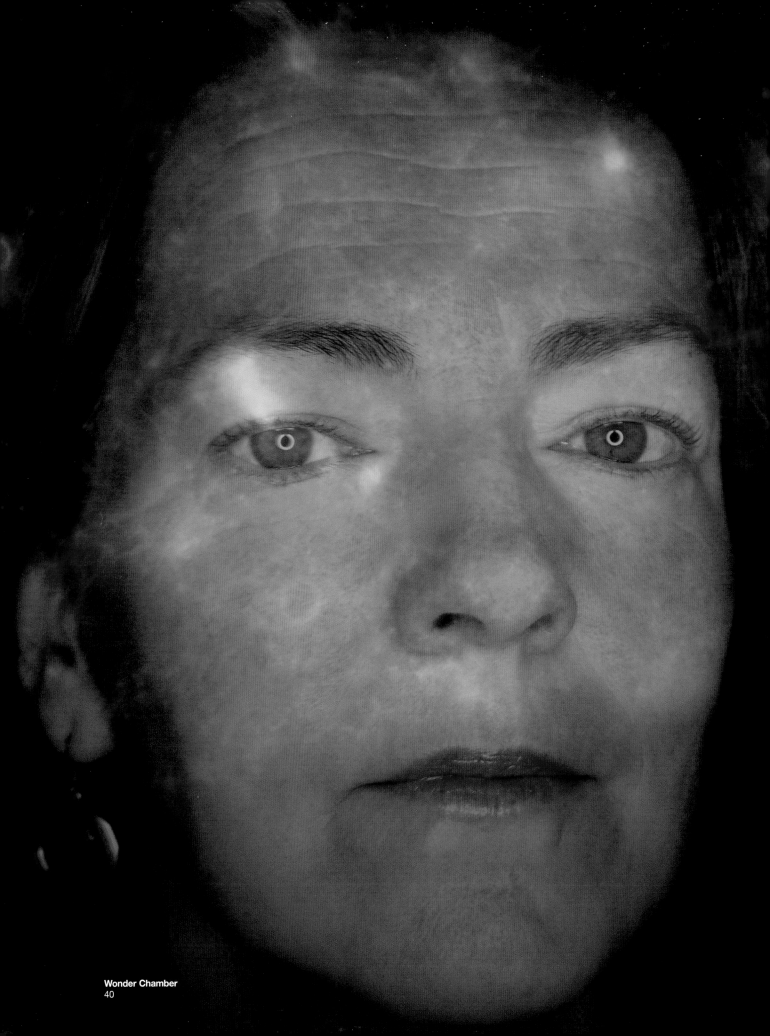

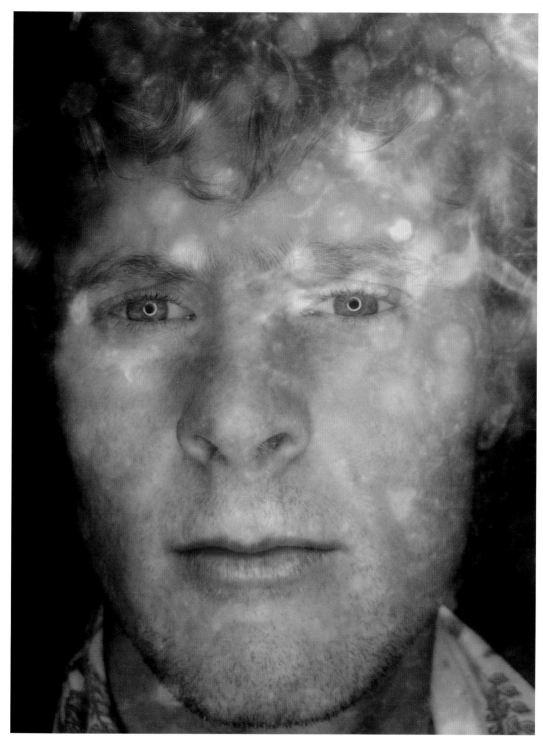

'Thought Portrait: Jack', (2011)

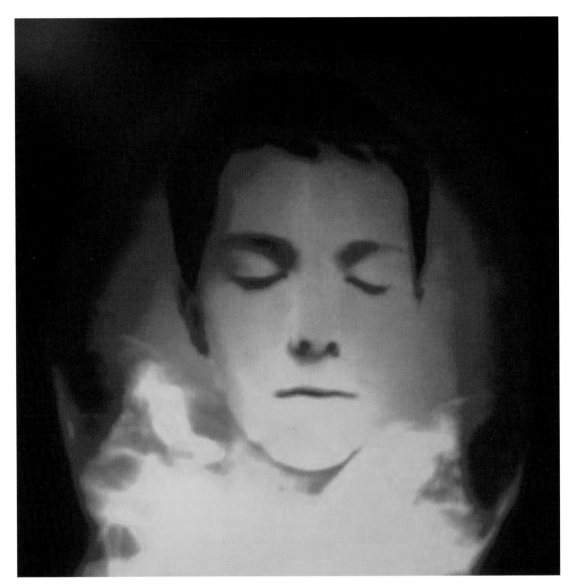

Film still from 'Vanitas: Seed-Head', (2005)

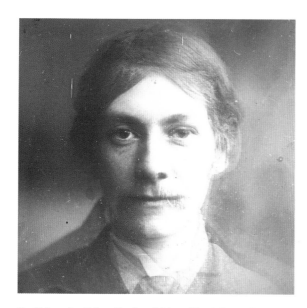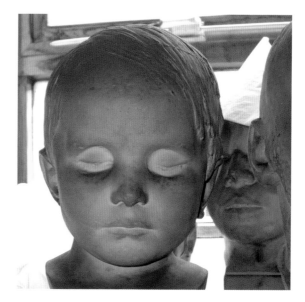

Two Mothers, Two Fathers, Two Sons (left image) Death Mask of Child, both from the UCL Galton Collection

Vanitas: Seed-Head

Originally screened as part of an artist in residence
installation at De Waag, Amsterdam (April 2005)
'Vanitas: Seed-Head' developed from discussion
with neuroscientists and stem cell researchers
during the artist's Science and Art Fellowship with
Cardiff's Neuroscience Research Group in 2005/6.
In his description of stem cell research Kevin Fox
describes how: "All cells of the brain are formed
from a single initial pluripotential cell…a 'stem cell is
a cell early in this hierarchy that retains the capacity
to reproduce copies of itself.' Contemporary
genetics owes a great deal to Gregor Mendel's
inheritance studies, which were an important
catalyst in Francis Galton's research into inheritance
and proto-genetics. These connections are explored
in 'Vanitas: Seed-Head' through a series of
computer morphed transitions between the faces of
the artist, her partner and their son: a replicating
lineage. These were then overlaid with an x-ray of
the artist's son's skull and projected against the
'coma blue' of the medical teaching screen. The
notion of the stem cell is transcribed to the Dutch
floral Vanitas, alluding to an actual plant stem and
bulb, referencing the notion of the seed continuing a
genetic inheritance even as the parent/plant withers
and dies. There is another layer of meaning to the
artwork, that of transience and mutability. The
images, especially of the child, evoke Galton's death
mask collection, and indeed, the three photographic
portraits are in a sense death masks: a Vanitas
memento-mori on the fragility and transience of life.

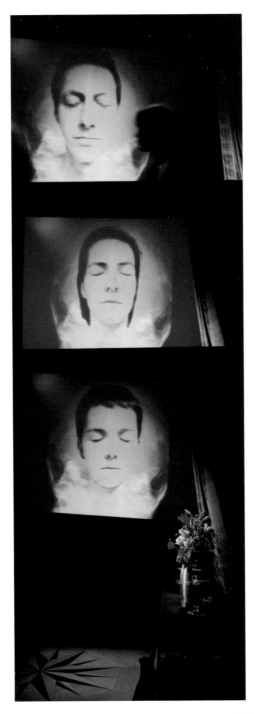

Installation shot, De Waag, Amsterdam, 'Vanitas: Seed-Head' (2005)

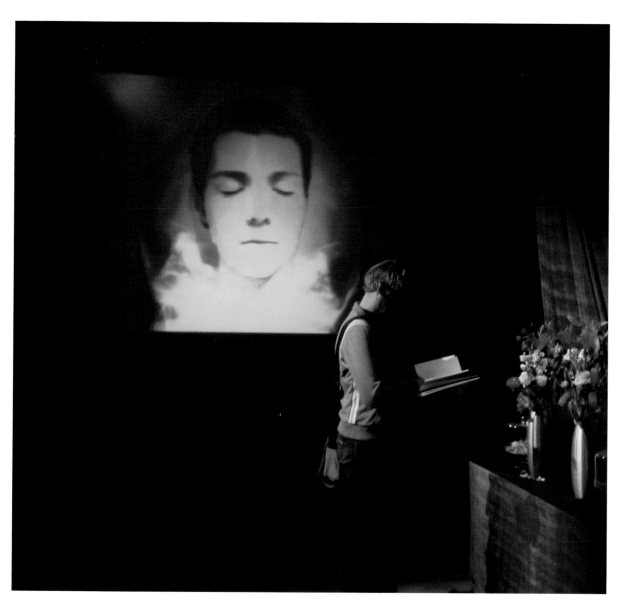

Installation shot, De Waag, Amsterdam, 'Vanitas: Seed-Head' (2005)

Michael John Gorman (2007)
Projecting Nature in Early Modern Europe

●● **The darkened room filled with optical projections, as it developed from Aristotle until the eighteenth century, was invested with a range of very different practices, including astronomy, theatre, steganography, magic, physiology, painting, optics, meditation, chorography and even warfare** ●●

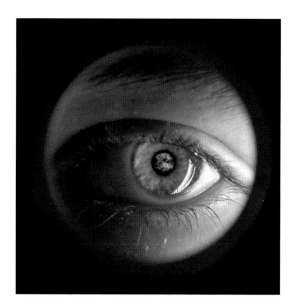

'Descartes Eye I' (2010)

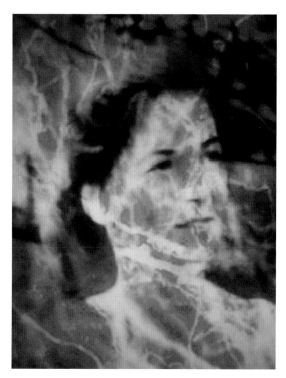

'In The Minds Eye (fuzzy mother thoughts)', (2009)

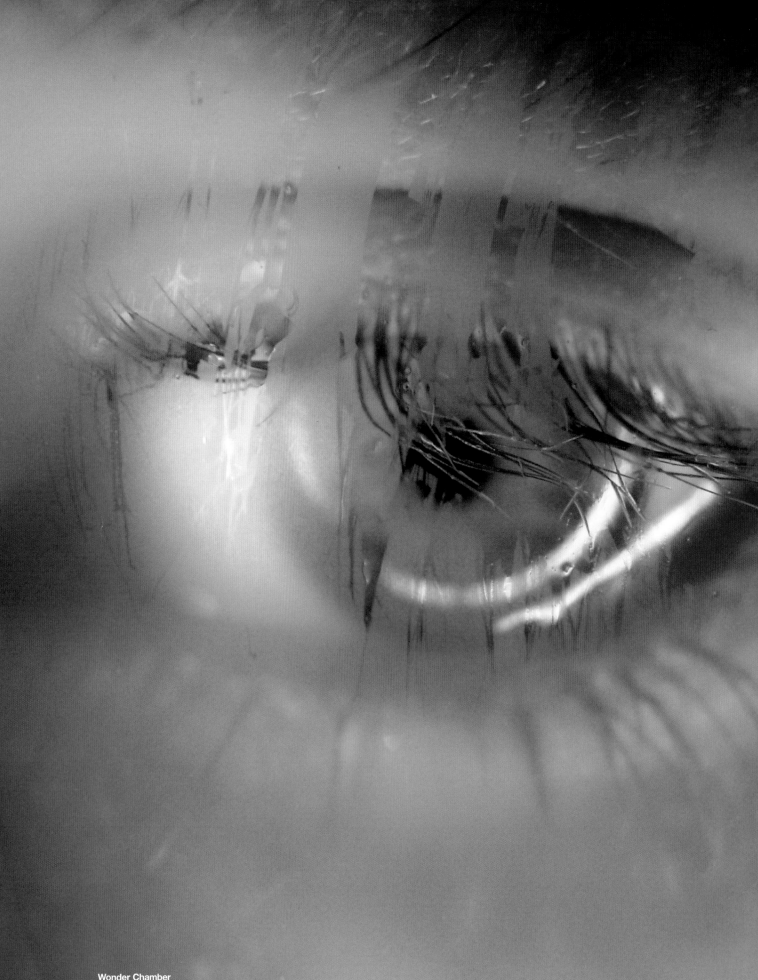

Cloak of Surveillance

'Cloak of Surveillance' is a prototype wearable technology artwork based on Galton's proto-biometric iris pattern recognition studies. His glass eye collection, with each eye eerily set into a metal moulded 'lid', is in itself an object loaded with narrative meaning and scientific history, but the eyes are also suggestive of our contemporary surveillance-obsessed society. Iris scanning biometrics has moved from science history and science fiction into the mainstream of identity recognition systems. The cloak also references an earlier historical image of surveillance and power; that of Oliver Isaac's 1600 portrait of Queen Elizabeth the 1st in her carnivalesque 'Rainbow Cloak' with its all seeing eyes. Fitted with a miniature spy camera, 'Cloak of Surveillance' returns the gaze of the unsuspecting viewing subject, projecting back to a monitor in another part of the gallery. Like the historical Panopticon, the subject does not know if and when s/he is being surveyed.

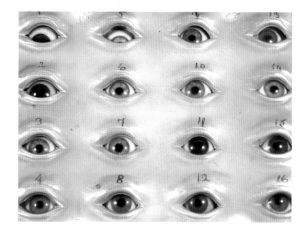

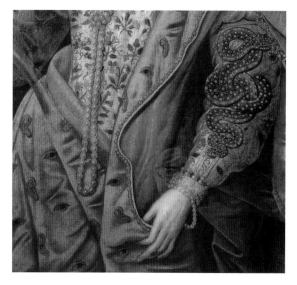

Galton's Glass Eyes (from the UCL Galton Collection) (2012) and detail from 'The Rainbow Portrait' (attributed to Isaac Oliver 1600)

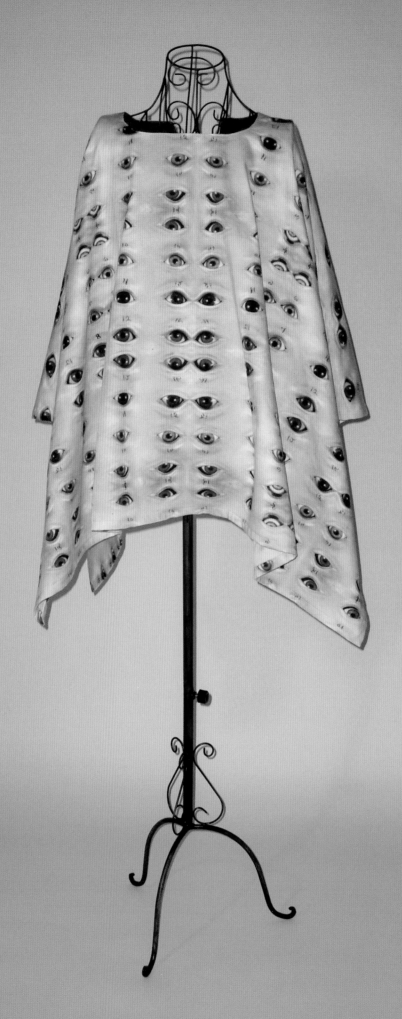

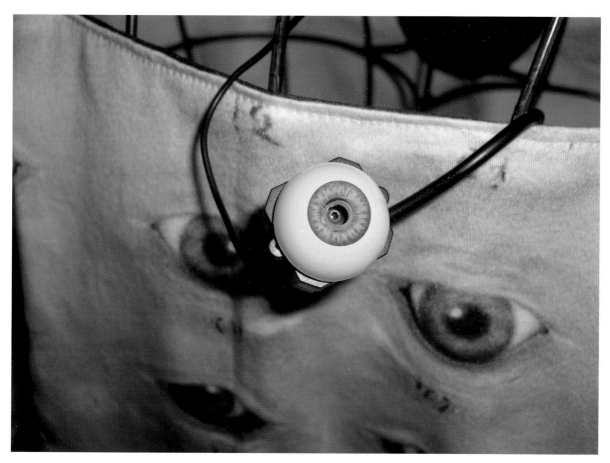

Detail, 'Cloak of Surveillance' (2012)

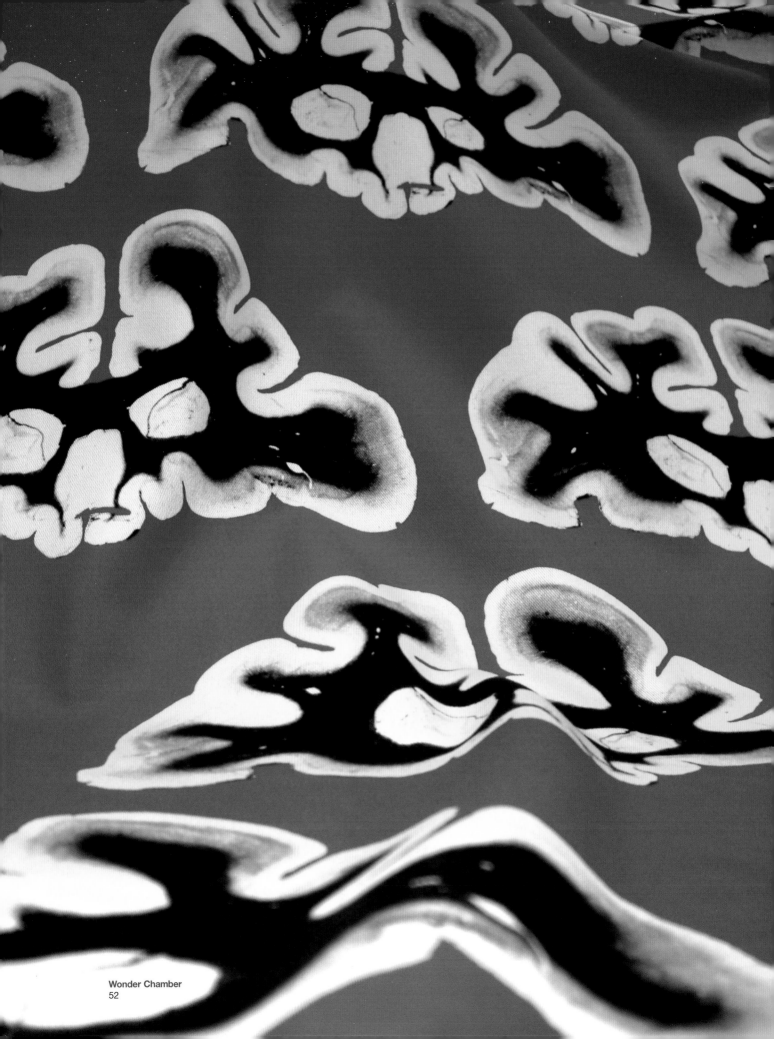

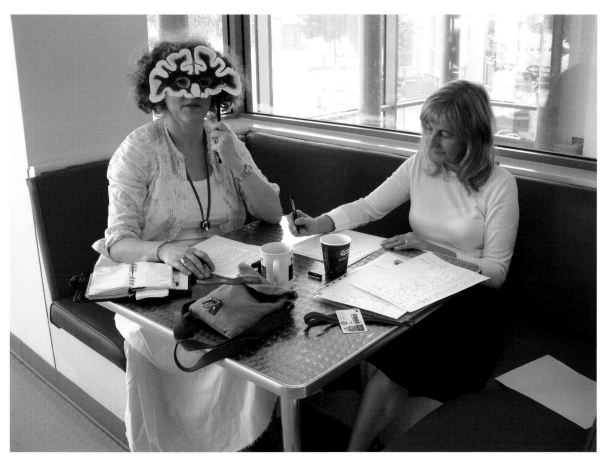

'Piece of Mind Mask' Performance Still (2010)

Piece of Mind Mask

Medical imaging and digital representations of the brain have led to an unprecedented expansion in anatomical knowledge with biological imaging exploring ever deeper into the interior of the brain. In terms of neuroscience molecular levels of investigation bring 'mind to matter' through new wonders of technology that allegedly can read our very thoughts and measure our most secret impulses. However, how does this neo-technical enlightenment help us to further our understanding of personal identity and does being able to allegedly 'see' our thoughts really give us 'peace' of mind, or is all we are really looking at a 'piece' of mind? The 'Piece of Mind Mask' series is a playful and performative provocation that takes the mind/brain debate into the 'theatre of the mind', an imaginary wonder chamber in which four anatomical brain slices are transformed into carnivalesque masks, reminiscent of the Venice carnival. In addition to the four giclee prints, the masks are available as a free download and can be printed and 'customised' via the ancillary web project 'Colour My Thoughts' on page 58.

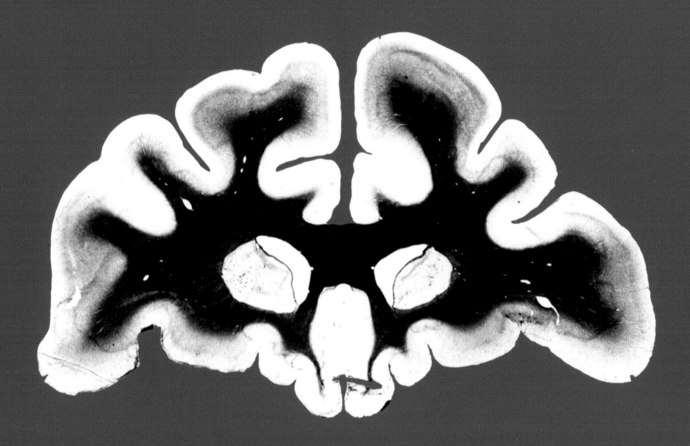

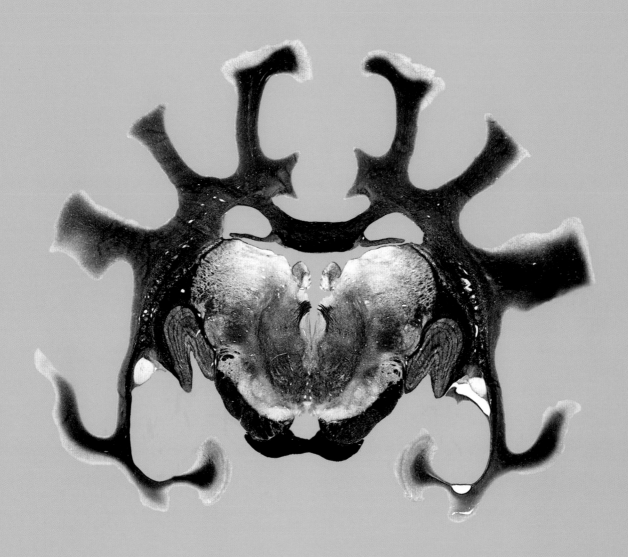

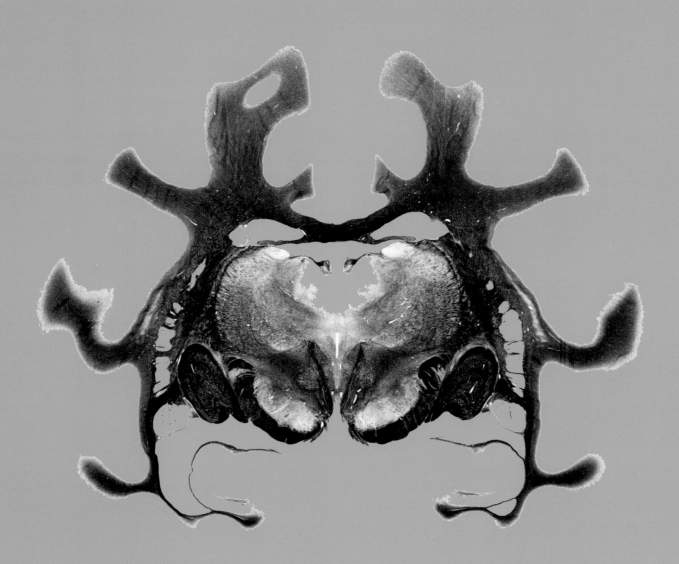

Piece of Mind Mask (Green), (2012)

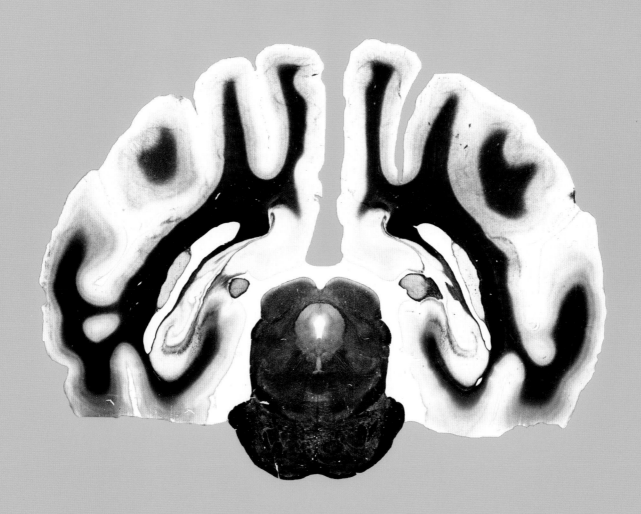

Colour My Thoughts: 'Piece of Mind Mask'
Participatory Web Project

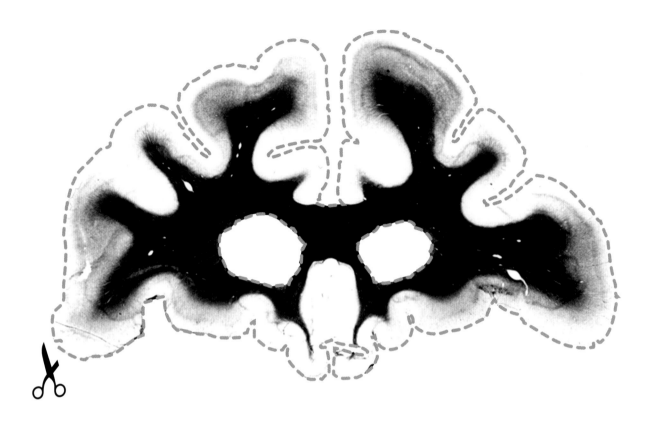

If peace of mind evades you why not settle for a piece of mind in the form of a downloadable, printable version of the Piece of Mind Mask. If you visit the Colour My Thoughts web link you can print and cut out my monochrome mind mask and colour and customize it, transforming my thoughts into yours. You are then invited to take a snap of yourself wearing the mask and send it back via the web link so that a gallery of participant images can be created.

http://www.ffotogallery.org/colour-my-thoughts

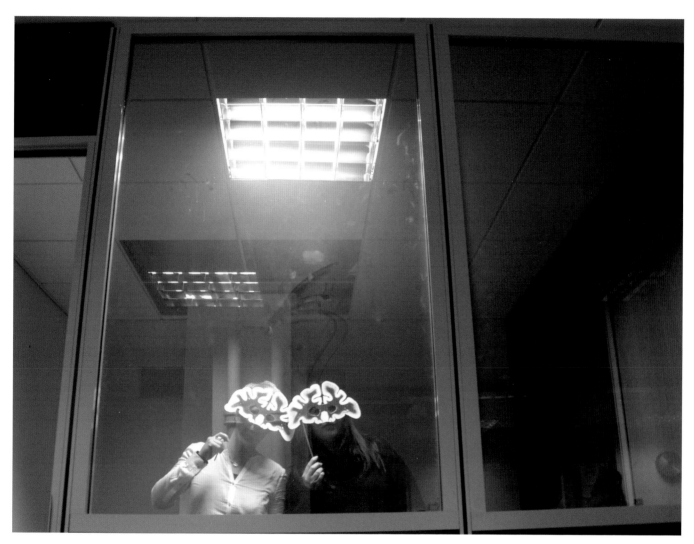

'Piece of Mind Mask' Performative Intervention (2011)

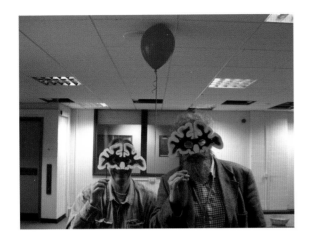
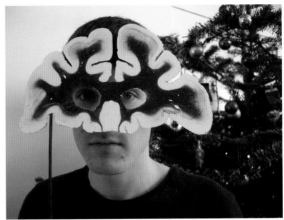
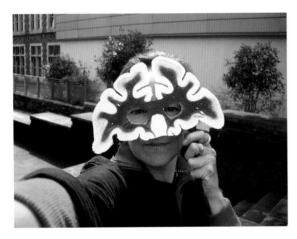
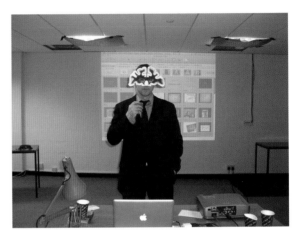
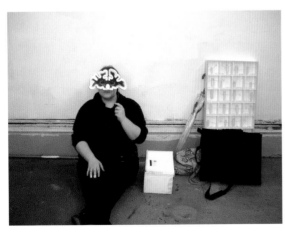
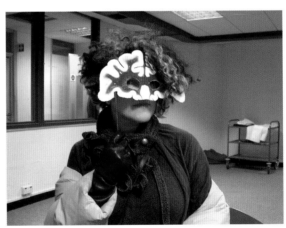

'Piece of Mind Mask' Performative Interventions (2012)

The Wonder of Things
Karen Ingham

There was a time in my early childhood when curious objects, wondrous spectacles and obscure science were a normal part of family life. As the granddaughter of Spiritualist mediums I witnessed how seemingly ordinary objects could be transformed into vehicles of agency and narrative disclosure as part of the Spiritualist ritual of communicating with the dead. An old brass bell, a plaster owl, a feather head dress, a dried flower, and in particular, photographic portraits of the dearly departed – objects which seemed to convey the voices of the dead from an unknown world of veiled presences and amorphous forms. Spiritualism resonated with references to the ether, ectoplasm and aura, strange and exotic notions that were often linked to photographic manipulations of the deceased.

This fascination with spectacle, science and materiality is a major theme in my lens-based practice. In Wonder Chamber I am interested in the manufacture of illusion, sometimes fusing the imaginary and the real to create hybrid images that bring into question the philosophies, histories and paradigms of science. While these influences are expressed most vividly in artworks such as 'Narrative Remains' (2009) and 'Variance' (2011) they are evident in much earlier work, such as 'Death's Witness' (2000). Wonder Chamber brings together new and recent pieces that explore how art, science, and nature work together to offer us conundrums and hypotheses about how we organise and classify our knowledge of the world, despite the fact we live

in the most rational and scientifically advanced of times. Or, perhaps it is because we live in such a technologically advanced age that we secretly desire that residue of 'the wondrous unknown' from our unenlightened past. It enables us to shake a metaphorical shamanistic stick at rationality and reason by playing with pre-enlightenment eclecticism and curiosity. The *Wunderkammer* (translated as 'chamber' or 'room of wonders' and closely associated with the *Kunstkammer* or 'art room') and Cabinets of Curiosity were important precursors of not only the modern museum but also modern scientific enquiry. How we came to know and order the world was a project that required not only great ingenuity but also comprehensive networking and collaboration, and what we would now call transdisciplinarity. Much of my practice over the past decade has focused on creating collaborative relationships that seek to reinvigorate the eclecticism, the experimentation and the speculative imagination that was abundant in pre-modernity but has been all but 'reasoned out' of our discipline specialist era. Many of these collaborations have involved partnerships across bioscience and neuroscience where medical imaging technologies probe ever deeper into what it is to be human and this is much in evidence in several of the works in Wonder Chamber.

Just as with the original *Wunderkammer* my Wonder Chamber acts as a kind of imaginary museum with its interconnected spaces for the display of seemingly disparate and eclectic objects and

artefacts. However, my Wonder Chamber is filled with images - representations of things rather than the things themselves - that I have fashioned out of curiosity at the narratives the original objects suggest, be that a tray of dissecting pins, a dead bird, or a human organ in a jar. The ordering of nature and in particular the oxymoronic notion of 'natural history' is another prevailing theme to which I am repeatedly drawn. The Wunderkammer and Cabinets of Curiosity were early attempts at creating order out of the seeming chaos of the natural world with its marvels and monsters.

This is alluded to in the images in the 'Unnatural Histories Gallery' and in the video work 'Cabinet' (2011), which hints at the perils of species extinction (a concern of both the Cabinet and contemporary museums, which act as repositories of the extinct).

The museum, photography, positivism, and modern physiology all came into being at approximately the same time around the 1830's and were organised along similar ordering principles; principles that reinforced the ideologies of the status quo. The Victorian polymath Francis Galton, cousin of Charles Darwin, played a key role in the development of forensics, anthropometrics and psychology, and was also a keen supporter of Spiritualism and Spiritualist photography (which may have influenced his ghostly and misguided composite photographic typologies). His influence on my practice can be seen in several of the artworks included in Wonder Chamber such as the 'Variance' (2011) series, based on my collaboration in 2010 with the UCL Galton

Collection. Objects such as his composite photographs and his glass eye collection bring into question the histories and narratives of biomedical imaging in relation to identity and an earlier Galton inspired work, 'Vanitas: Seed-Head' (2005), made in response to Galton's death mask collection and his work on proto-genetics, is also included.

There is one final aspect to Wonder Chamber that may not be immediately apparent, and that is in its reference to the camera obscura (also a chamber or room from the Latin camera). In 1604 Johannes Kepler witnessed a spectacular experiment during a visit to a Kunstkammer in Dresden, which would prove pivotal to the development of his new theory of optical vision: the experiment was in fact a demonstration of how vision is formed inside a camera obscura. The 15th century Jesuit priest Christoph Scheiner described the camera obscura as "…merely an artificial dead eye" and both he and Rene Descartes instructed their readers to take an eye, preferably extracted from a fresh cadaver, and to adapt it so as to create a lens for the camera obscura and thus evoke 'pleasure and wonder'. In this mimetic side show in which life is brought into form and focus inside the darkened chamber, the disembodied eye-lens looks outwards towards reason and rationality while the inner 'mind's eye' looks to intuition and sensation. My Wonder Chamber is also a space where the Cartesian 'mind's eye' is metaphorically and materially embodied as is evident in the series 'Piece of Mind Mask' (2011) and 'Surveillance Cloak' (2012), which

also references Galton's research into biometric iris recognition and Elizabeth the First's 'Rainbow Cloak' with its all seeing eyes. 'Piece of Mind Mask' includes a performative public engagement element, which can be accessed via the web link printed on page 58.

Perhaps we are entering a new age of the Wonder Chamber? 21st century museums have become extraordinary laboratories of change and the definitions and boundaries between notions of the museum, the art gallery, the science lab and even the cinematic space, is increasingly blurred. I would like to think that this is indicative of a wider cultural shift away from strict linear specialisations across science and the humanities, a product of the 20th century as epitomized in the 'Two Cultures' divide as coined by C.P. Snow in his seminal 1959 lecture. Perhaps our 21st century understanding is more transdisciplinary - one might even say, a more embodied conceptualisation - of how we collect, display, narrate and archive our experience of the world; a process in which photography is richly entwined.

Karen Ingham is an artist, a writer and a Reader in Art and Science Interactions at Swansea Metropolitan University

Lorraine Daston and Katherine Park (1998)
Wonders and the Order of Nature

❝Rene Descartes called wonder the first of the passions...Francis Bacon included a "history of marvels" in his programme for reforming natural philosophy. Their focus on wonder and wonders in the study of nature marked a unique moment in the history of European philosophy, unprecedented and unrepeated. But before and after this moment, wonder and wonders hovered at the edges of scientific inquiry. Indeed, they defined those edges, both objectively and subjectively. Wonders as a passion registered the line between the known and the unknown...❞

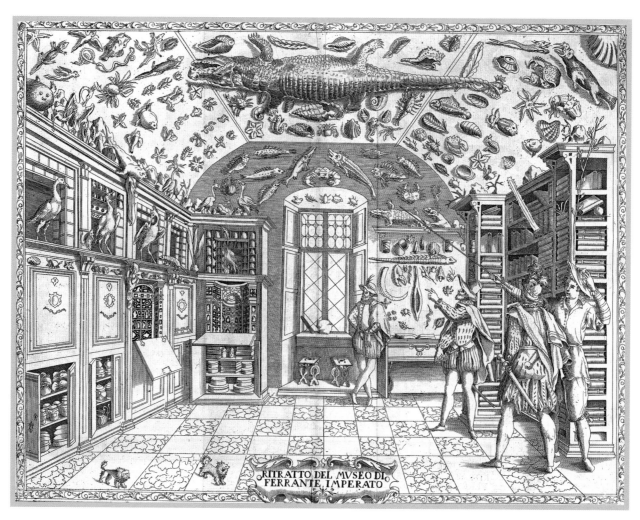

Wunderkammer of Ferrante Imperato, Naples, 1599. Courtesy of The Wellcome Library

Acknowledgements

In a project such as 'Wonder Chamber', which spans a period of several years in terms of research, development and production, there are many people to thank and acknowledge. In terms of funding, the support of the Arts Council of Wales has been invaluable with a Major Creative Wales Award in 2009 providing the much needed time and resources to develop many of the new works included. I would also like to acknowledge the financial assistance of The Dynevor Centre for Art, Design and Media at Swansea Metropolitan University, and in particular, to thank Professor Andrea Liggins and Professor Howard Riley for their continuing support. The production of the photographic and digital artworks was made possible with the assistance of Sarah Tierney, Christine Shaw, Manolo Lozano, James Morgan, Tim Stokes, Hamish Gane and Paul Duerinckx, and I am, as ever, grateful for their help. Several of the new artworks were made through collaboration with Natasha McEnroe and the UCL Galton Collection and I would like to thank Natasha for her generosity in allowing me access to the Galton archive and artefacts. Simon Chaplin, currently Head of The Wellcome Library, was instrumental in the development and realization of 'Narrative Remains' through his role as Director of the London Hunterian Museum, and I would like to thank him for his support. Also at the Wellcome Trust, I would like to thank Ken Arnold, Head of The Wellcome Collection, for his wonderful introductory essay. The 'Cloak of Surveillance' piece could not have been made without the help of Clare Ford and James Morgan who were crucial in making sure the concept could be translated from sketch to actual working prototype. The 'Piece of Mind Mask' series and 'Variance' were made possible through the collaboration of the Cardiff Neuroscience Research Group who helped me develop the initial concepts during my AHRC Art and Science Research Fellowship with the department in 2006 (although it took several years to find the time and funding to realize the ideas). I would like to thank Tom Smith for assisting with the installation of the show, which he took on despite juggling three jobs! All of the staff and volunteers at Ffotogallery have been, as always, professional, competent, and creative in the planning and realization of 'Wonder Chamber' and I would especially like to thank David Drake, Director of Ffotogallery, for his insight and expertise in curating the show and in overseeing and contributing to the accompanying publication. My publication designer, a collaborator on many of my past projects, Phil Thomas is owed a big thank you for his book design and his patience with my last minute changes and tweeks. Last but not least, I want to thank my collaborative subjects, all of whom are family, for their continuing patience and support: Samantha Marrian, Emily Marrian, Jack Marrian, Hunter Marrian, and especially my partner and son, James Morgan and Harley Morgan, for allowing me to put them into strange and at times uncomfortable situations in order to realize my vision. Thank you.